No no the saddest

No no the saddest

poems

*for a fellow traveller
in life's odd journeys*

Alan Bern

Alan Bern

2004 / Fithian Press, McKinleyville, California

Acknowledgments

Lo Sciacallo: Trivestrale di Cultura, Scrittura, e Responsabilità
(http://www.losciacallo.it/Archivio/Sciacallo5/NOTTE3-BERN.htm)
Fall 2001: WILDWOOD; Red is Fugitive; Color Correction;
Light, bright or soft

Published by Fithian Press
A division of Daniel and Daniel, Publishers, Inc.
Post Office Box 2790
McKinleyville, CA 95519
www.danielpublishing.com

LIBRARY OF CONGRESS CATALOGING-IN-PUBLICATION DATA
Bern, Alan.
 No no the saddest : poems / by Alan Bern.
 p. cm.
 ISBN 1-56474-433-7 (pbk. : alk. paper)
 1. Coma—Patients—Poetry. 2. Pregnant women—Poetry. 3. Child-
birth—Poetry. 4. Marriage—Poetry. 5. Grief—Poetry. I. Title.
 PS3602.E759N6 2004
 811'.6—dc21
 2003013445

Dedication

To my dear friends and family
who saw that I lived through

To PR , JK, and AW
who sat and listened

To Thaisa Frank
who made sure this happened

To my dear son Jake
accomplished actor, juggler,
and kind human being

With deepest gratitude and respect,
to Alice Ruth,
who helped me love again

No no the saddest

No no the saddest
is when your young husband goes
and you still hear his voice
slurring in your ear

No no the saddest
is when your unborn baby dies
even before she can be born
and washes out of you like hot water

No no the saddest
is when your old parent begs
to stay home with you and live,
but you have to put him in a home
where he soon gives up and dies

No no the saddest
is when you outlive a child
who's suddenly twenty and
on the edge of finding out things

No no the saddest
is when your wife goes full
length into final coma and you warehouse her,
your visits dwindling as she locks in

Days Before
Days Ahead

Spy Class, Hill

Eyes binocled through to
a hill
where a small girl
is sitting, butt back
in the sandy soil,
no wet goo
on her yellow shirt.
Her gnashing language
tells three things about her:
knees crossing and kicking out are joyous;
the little animals in her hands have not been bitten;
she is alone, what I've seen.
The wrinkling of her face freezes
me.

Call up a paper so smooth
that
letter-making moves
are quick, firm, and easier
words. And soft, this tissue
so that the issue
is fast forever sculpture.
Who wanders in the pits
and pulls of this written
wit? Is this mold pre-bitten
and grain-aware?
Is the wanderer
creature or human touch?
I will enter here
with it whoever
and go
talking friendly
with you
down an avenue
wet & dark.

Meeting

What I first knew was your sweetness.
You laughed
at me, at the badtime world.

Second, I spelled an extra letter
 to your name,
silent suggestion
to speak more clearly,
twins in fluent code.

The Liberation
of the Lap-Dog

I'm your lap-dog, love;
push me off the little cliffs
of your knees,
and I'm back.

Push again,
and I'm beside myself.

PUSH–PUSHING–PUSHED

I

Yarn spun in
separate threads.
I loved you like a shark to fresh blood.
The wounds I opened were doors
to a hooded bridge.
I bit you like crusts of hard bread,
struggled with your Jenny spindles,
and sang several rounds to keep
my full neck active.
I had to go it all alone,
winding out the path.
When I had mangled every music,
the solitude spun me like a Mule.

II

I loved you. (You loved me.) We were sharks to fresh blood.
(I was in black & white, slow motions.) You were colored &
striped, many frames in those seconds. We obliterated all
simple truths, through a slow combing, carding out dirt
and knot; and took to rugs, single but whole, intricate
designs. Voices burned through our joining throats,
and our music kicked at every stretch and turn of our
Spinning Jack in carriage of one thousand bobbins.
We had patterned every center. The wool its own Loom.

Vertigrasp:

Memory of when you loved me, endurance

What I think I saw
 makes me dizzy now.

First, when you kissed me hard,
 a pencil pushed by hand

into binder paper,
 I stepped back to enter.

Firefly-at-my-loins,
 your lipteeth on my neck

touch bruisecolor
 around it, tipping the mainland,

you are combing, claiming it
 toward a finer edge.

You wave your hands
like lanterns, good-bye.

Mountain Love

I have left you our Grand Teton Playing Cards
in remembrance
of our sweep across America:
before love a hand of Gin.

We missed those mountains
in our hook south, but

how we bend up those mountains now
in anticipation
of a good
 hand!
When you go out
with one or two or four,
I'm out with one.

We find those mountains
on our next sweep.

I want to speak easily of the stories
 hands tell when they hold immobile information
 in cracks, in crevices, and in pores.

I refer to grease and to the formation
 of increased strength from pushing, at first,
 small metal objects into place.

This delicate work is done by forcing
 them forward without breaking or bending
 as I fit your car with its condenser.

Lynn, you always loved my hands and held them
 in yours, but you especially longed for
 the rough-cut edges and the stains from grime.

Crack glass

For the secular event

Few invited, few attended.
Your wild mother'd warned us twice
of the cut instep, torn sock.
Now, *I do's* done, we faced the cloths,
raised, poised our feet, stomped down hard.
The glass from Kress bounced right back.
Then, stamped again, a splintered pop,
coughing, shards.
 A spell broken.

heart felt

I put my sweet
heart in your flat hand;
fingers curl softly
into ventricles, auricles and
the soothing
is moving that muscle,
my desire, your chambers,
those four laborers.

A Headache Speaks

In the flimsy motel,
Meet John Doe finishing on the tube,
you roll eyes, hold your face,
this is not the moan of deep pleasure
though next door they know nothing.
 I do know,
now, it lasts days. I hold you
in comfort, lay my palms to your temples.
"Not there." Not there.

Trap-Door

Bright Before

to the Nederlands Dans Theater

I

Multiple signals, red-to-green,
code toward yellow,
together, danger though precious,
but now a thought before us,
so bright, dark bulb.

II

Backlighting so blinding
the light face disappears.
How is this one to speak now?
Holding up six fingers
in this shortened pageant,
two hands blend to one.

COMA

I wish I were wetter;
and the weather desperate
at my back knows no
other wind but yours, love.
When I walk
 this is too new
your lying there
 there, but not
in the room
 bed
 posture you're aware
Your brain fever burns, blows
Santa Ana dries me out.

Brain Song: Bleed

Stretch wide,
oh weakening wall,
but by all means
do not tear
apart. Every drop you leak
is winding slowly for the kill.

Love flows through us like blood.
Yielding to the impulse, there is danger.

as predictable as turning
a corner…

The tired beast beats
time and lifts a head
for every small death
we live. Deaths grow
to kill us and life eats
what it needs
and moves when it is done
feeding time with small coins.

There is a newer limbo
uncreated by a waiting
from the bleeding of a heel
(small and weak in the brain)
as of Achilles: aneurysm
is the fastest name for
pressure building
its blood trap in the skull.
And how it fills and fills:
to release its message, bore.
Remember the head together
again, oh Doctor Drill,
then put her back together again.

to Robert Fink, M.D., F.A.C.S.
on April 29, 1979

Waiting Room

In the waiting room we spill
sweet soda endlessly
over the plastic. The thrill—
Doctor Pepper entering.

I have a heart for this mess:
beat-skipping through the hallway
into the waiting room:
then, slump-chaired, gazing out
through glass at the mute town.

To Lynn, in Sleep Neurological

You went in, bleeding to the skull,
pleading that your baby stay within you.
And it did and you bled.
And it has and you live.
And it's safe and you're due.

Then I didn't know the language you chewed,
losing letters to convulsions,
but that cool washcloth, I handed to you,
my gift,
wiped your face by your hand that has not moved
by your waking mind
since.

If you wake, you will be lovely,
and I will thank the coma that cleansed you.

Brain Surgeon:
Cut Open

Go to sleep within the sleep
that masked one gives to you.

Remain in sleep far deep
to feel the edge run on
in through bone and brain to make
another dream's no sound.

Boxae

Another rapid child fills
a shoe box up with sand and
thinks each grain a voice:
 this is
how it is to talk to you.

When I whisper in your ear,
this is what hears:
an under-sleeping window
box unlocked.

A human echocave: Ear
of Dionysius, stone deaf.
Fixed Black Box who speaks in zero
hears messages to the dead.

I hang on to your aside face
by tearing off my last nail:
where are you traveling? In place
of love, I drip the blood pail.

Zed End—Coma
BRAIN-SWELLING

Your body comes abruptly
to edge, the brain stem stinging
in wait-days: time flies inning
after play, your stopped thought is.

Leaning In

to the comatose

Leaning down and in
to approximate you.
How close can my face become?
I do not ask that
you wake up. That story
is never ending.
Still, as if to kiss your lids,
I purse my lips.

ONLY MY SCREAMS CAN SEND
DREAMS DOWN TO YOUR DROWNED
INFLUENCE.

ALL DREAMS NEUROSURGICAL,
ENVYING MAGICIANS
THEIR INTERPRETING SAW SKILLS:
CUT, WAKENED IN A KNOT SCENE.

Herrick Hospital, 1979

Emergency Surgery
gave you life back: Intensive
Care machined your moves, O
Little City Hospital!

A Secret Mind

Driving on a broad street
under the cover of a track,
I am lodged down,
lose all outward sight,
stop the car, rock back & forth.
At first, I weep, cry out, yell, shriek,
but it sits:
there is death and there is worse.
Then a calm comes,
my body softens
my focus to an inside
where I can hide forever.
Under the wood stairs,
there no one walks,
eternal visitation.
No cool passage leads away.

Nurse Song

There is no other life source
as rich in choices as this:
"I shall give you with every
part of me pure sustenance."

Sink unconscious:
 Flat Path Land

Life is better left
than traveled flat scan
on a grey-top road slow
in its silence, lower
for its crawling along
flagless without peak or strong
canyon descent. Go down
now assent.

Spasmatic

Muscles writhe through your body
like excited snakes, even
breathing strikes unevenly:
Limbs, organs, twitch in this fever.

Yet Stroke, Struck

NOW I LOOK LONG EYES
INTO YOUR EYES,
GREY-DAZED, FIXED

The brain has clear, smooth spots,
as the river, waveless, clean
from lack of wind.
There, memory is rubbed away
by serene air, but there too is death
without the movement thought craves,
and beneath this surface no fish swims.

Death Study:
Mystery Trap

Trapping, a technical term
in printing, concerns ink pigments
sealing over one another

IF THE BRAIN STEM TICKS
ONE LAST TIME TO LOBES AND SPINE:
LET THIS ELECTRICAL SHORT.
WHITE, THE PERFECT BRAIN LOCKED IN.

Black Out:
Death Sex Alone

Half-stiff
I put tender pressure
on this prick-tip
pulling, flattening, moving back in
to the bed then
straightening out
coming forward faster
in the palm-hold
the yelling pushing
out
but
right before peak,
the black flat cube
flying in my eye
like air, like nothing
else, like fear,
wet and soft on the face;
but that forthful terror,
her lips to my left temple
yells and yells
telling me the same off story.

Watering the grass holds me together:
I have the weight to fall among the blades
of sharp grass, but this strong smell
of mowing, hosing, and of pulling
weeds keeps me standing still
along the edge of pavement
and the lawn.

That particular misting coats by inches
every surface.
 I stay afloat
atop and water the lawns
of grass and even the weeds as you pull them.

Bleed

I

My shriek
ice-treasure,
breath up my chest,
all tight.

When your brain first bled,
you reached for other blood,
thinking you'd
miscarried.

II

What caused
that rupture? Your
pregnancy from our making love
on a fall night?
From your thought and need,
some rare act
your body takes?

Classes failed

My first class failed,
Italian Stenography
in Liceo,
was mere exercise
in graphic disarray.
I looked at that language
and laughed out loud.

My second class I failed,
Birthing for Couples,
in the hospital alone.
I cried out in the hall
afterwards:
you in coma
burning with fever
laid on an ice blanket
to steady the baby.

Zoologist

There are other animals
to consider in place of
Man. The problem again is
how unique this thinking is.

I am afraid
your head
will blow
again,
and I'll
be left
alone.
Could you please
come with me,
now sing sweetly
"I'm the one,"
and then
leave easily.
The door
is open,
your will
is broken,
my love
spoken.

Choice :: Fantasia

July 29, 1979,
written the day before
the birth of our son, Jacob Bern

I

Knowing living
in the then and now
and then
it happens: a button
before you: to push it
forward from you,
your shirt bursts open
and there you are
born. Finger

II

knows furry surfaces, you
rub in circlings
your softest belly.
Looking long
into the mirror, the baby
head crowns as wet leaves
and the soft mosses
fall about your head,
filling your ears
with the moistening
noise of breath.

What Was

Sometimes a woman's body
simply has a baby
said your loyal doctor
and you did.

No OB nurse
knew your body,
semi-comatose.
I became the missing link
in the birth parade,
a mad technician
cranking your ankles
to loosen your thighs
open. Your body
a miracle machine.

I called the drop,
held the little marvel,
and went back without you
to your first ICU nurses
to celebrate.

Through Sickness

Write through the sickness
until life takes off
hair from your head.

Peace

Two pieces' jingle, one's still,
yet one moves, though quietly.
I am afraid of your breath
with mine, a threat of reaction
between us. You will not be worn
down. That means I am softer
substance. Leave me in pocket;
go out, hunt for big game.
Yes, when I roll, I'll miss you,
but this is a first hint.
Come back to me over-loaded,
and we'll celebrate like black
widows whose chromosomes
are confused and cannot read.

The Furies

One disenchanted evening
I could have smothered your sagging mouth
with your special pillow.

How could you have done this to me?
In my sleep I reach for chloroform.

Does your family carry the devils?

The furious Greeks understood this,
required murder of husband, wife, child.

Mourning Block

Possible to ward around it,
but it is never square at edges.
It is not square.
 Putting my head to it
there is no blade comes to sever.

The houses on it are an open window.
Glass rattles, asks me in.
 Who cannot enter?

A cold sun rises, twice blinks, and sets.

Death Sex 1: Nurse

When you take me in your mouth,
I take you in mine.
This is the saddest part:
we are connected to someone
and slide crying
in each other's open arms,
but when we kiss lips,
after the passing back,
slow cum lumps fading,
the softness is only that.

NEVER DEEP ENOUGH DOWN

SMUGGLED IN, BELOW

They searched every spot by light,
but would not dig under,
since the surfaces glowed
and grabbed all attention.

Hidden, then, under the lot,
were the magnificent depths,
only referred to, never
actually seen, of the other art.

Still Life

In your electric bed, home-bound,
you lie still, and then move, always
sharply,
as in a vase of flowers
water will
when the table is bumped
and then stop.
 When wind
finds the open window
and dusts the room into corners,
old petals pass onto the floor.
Will you die in this odd confusion,
or is this wind-blown condition
a sign that all is stable?

I begin to sweep up.

Death Sex 2

To lie with a corpse is cold.
To lie with you, your brain gone,
is impossible.
 Humans
wonder, and you cannot.

We pretend. You call me *Alan*,
the one from your 6th grade class.
Between the heat of leg spasms,
I fumble myself into you.

You say, *I am a virgin*,
as we make up this entry.
Because it did not happen,
has not happened
 to you.

Bitter

The bite takes hold
like rampant mold,
grows even in the cold,
shadows the bold
outlines of old
blue eyes. I'm told
this story rolled
from a book sold
for little gold.

How eyelids fold
around the acrid.

Death Sex 3

I

The blonde wanted a meal of me,
we lie on your electric bed at home
and eat slowly of each other,
sweet, soft fruits from soup plates.
If I am slow to answer,
remember:
I look deep into myself
to find a flat plane,
a sorrowing waste, mundane.

When I cry out to her,
 my cock in her mouth,
my true tears come.
I am grateful
 in despair.
I fall asleep
 as if I'd nursed from her,
lie still in her soft mouth
 tonight.

II

Much more the more I expect,
her little valise unpacks.
Now she faces the mirror,
low for our rear entry:
both of us can handle this,
and we do, we need to kiss
so everyone here turns
and faces eventual
missionary fishing. We'll
catch, we hope, or else take turns.

A Secret Mind:
The Flat Mundane

The low valley
in the heat
leads to a great desert,
but survival is assured,
required.
Life lived is not rival
to this.

If there were something to climb,
 somewhere to stretch.

At edge, sad-teeth, off-eyes.
What beauty remains.
This is not a corner
of the earth,
but the depression,
the low world.

WILDWOOD

Hold you.
Hear the two voices
of the man in the room
adjacent, interrupting
each other, saying

> "There are only one of us
> *left to figure, finger.*"

Hold you.

Ode to the Nursing Home

To leave you is to kill you,
To leave you is to leave you with Hades,
and he will soon hurt you.
To leave you is to hurt you
directly on your flat heart,
still spinning, *flagrante*.

ANOTHER MORNING WALK

Here I am as they find me,
handcuffed to false memorials
for birth-slain mothers, the kids
miserable in their remorse.

I have seen you
a ghost and wished I had you
back years in time, a live wife

carrying a child around
inside you in the cool dawn
when worries were the checkbook
and a low tire.

On I come to finish out
my stride, but within a block
I am crying tear-for-step,
cannot stop. I face this wall.

Facing that hard rock, it
is something to climb over,
and the ice-wind at the top
pits me like a green cherry.

Red is Fugitive

In a chemical word
red is hardest to hold.
On the pigment-coated sheet
images in sun go green,
the most disturbing of the balances.
I saw a body
dead and iced. It was not blue,
but emerald.

In extremis the blood, too,
stops or goes off. And the flesh,
always a fitful balance,
goes grey, without light:
the red goes and the grey goes green.

What I Missed

I

Your body smooth,
through hair grown
by dilantin,
your eyes enlarged
shot out by damage behind,
your one-hand touch
to drooling lips,
trembling as the other side
snapped into spasmodic heat.

All this I missed
when you gave out and died
without me there.
 Oh Abbandonata,
I put you there, you chose
to die.
 You did.
I loved you still
though I had no one to tell,
voiceless.
The call from your Nursing Home
trying to find me, found my mother
instead. She told me.
I breathed out fully, again, finally,
impure relief, but relaxed, just.

II

They wrote, *Heart Failure*.
I felt, *broken down spirit*,
failed heart killed you.
Then, as quickly as I heard,
you were gone,
dragged by your damned parents
away & burned
before I could see you,
touch your body,
have your brain checked
one last chemical time.

III

To a large fine dark carriage
with a red platform within,
I would have lifted you,
carried you, bent woman,
shrunken, stiff and forever,
and laid you, finally,
a terrible princess, on it, cold,
then spurred the strongest tall steed
to ride whole, carriage and all
onto the pyre, the fire hot as any hell.
I would have jumped
ultimately away
and watched you drive to some peace.

Envoi:

Then, those ashes.
Taken to all locales:
L.A., Riverside, Boston, Palo Alto,
Berkeley, parts of your fair ashes,
dusts calm in the places spread.

Dream of Tangles

Now, downstairs with the laundry,
I hear again your voice softly tell,
I see the long large-sheets,
placed apart in the large load,
after the long spin,
have found each other
through the little pieces,
underwear, cases, light socks,
snaking toward, then tying in a swirl
together till I unwind them
and they dry, tumbling apart.

An Aftermath

Une Note Finale

Some pray for peace.
I pray against
this happening again.
With every release
there is a secret.
Here's one:
on your return
from the last Rehab,
the one far across the seas,
I would not meet your plane.
Failure was everywhere,
I wanted you to die.
Instead, I took your parents to eat,
drove home drunk,
while you seized for hours
in the Nursing Home,
then fell from your bed.

Nothing cracked your skull,
all damages within.

Then you turned
from screaming for food,
life-cries, to slow suicide.
Entirely silent,
refusing to metabolize.

Your histrionic mother
wrote 1000 illegible postcards,
scarcely visiting, blamed,
believed the Christian lady who visited you
at the very end
helped you to die,
smothered you.

I hold
you simply receded,
your last act,
fading away,
entirely alone.

BAGGAGE

Now that a noise
has left the body behind it,
why? And who stays
to interpret and to mind it?

The answer that
this only kingdom gives me now,
and sad's the fact,
Sit, listen, grateful like a prow:

when you love this sea,
take in all the salt that you can,
travel on to a next island.

Yelling :: Behavior

The neighbors complained
with voices dropped, shamed.

I

For years and after
your psychomimesis
kept me up at night,
rude echo
of your static then.
You slept days.

Our son slept soundly
at my parents'
while you,
my awful baby,
cried and yelled,
a mad, livid bird.

II

You told a tale
which began darkly,
a misbirth at dark noon
behind glass doors, frosted
and steamed from such panic.

Go, Desirous, with your next couple,
go to a movie, to late dinner.
Stand near them standing together.
Feed off their happy heat.
Talk with them as they talk.
No use tonight the turned earth,
the sky wobbles like a flat bird.
Couples falling, their loves hold them.
My feet dig around.

LMB

I've said you were dead past tears,
and told the lie for ten years.
Like a long rat in thick walls,
you've unrepentantly gnawed
through wire, board, and plaster
sometimes out loud.

This is our disaster:
I recognize your high calls
as you come back through. Your eyes fix
bead-to-bead with mine. Your breath sticks
to my glasses like bad soap.
You *are* dead; I cannot face you.
Real memory, you are dead hope.

Lapse of Light

Perhaps I do not mind
the filtering of all life
in pictures through tones, tints, lines
and dots of detail sharpened
by an eye, glass, or mirror.

I approach happiness back
in a metal chair before
a window peering through screen
at a tree in cement
island. While turning my head,
sunlight flashes chrome off a trunk
through the many leaves in winter,
through the open window glass,
through the bug-meshed screen into
my eyeglasses' plastic frame through
the lens and on into eyes
waiting, wishing for it with
all the longing a heart sends,
blood draining to a brain. Cells.

NEW LOVE

The dead ones are the best:
they don't jar my arm
while I'm driving the car.
They won't help me invest,
but they don't take my cash
while I'm asleep, or splash
soap in my face in the bath.

But I will lose my fortune
soon enough, sing a tune
out of key in a stalled car,
and run out of hot water
in a filthy grey tub.
So I embrace my new bride, love
her till my heart is tired,
know her full empire,
and take the phone off the hook.

weeping grief ice grief

We are still apart, the center
of the circle is a pit
veering left and right away
coming to a point
far off in spits of ice
deep and away:
tears drop down miles
below, and stop
on a side of face,
and hold on tight
grasping at that facet,
easing slowly to the tip.

Color Correction

Away from your face
at last, a new surface.
It is like a tree
or leaves: to lose
one is the smallest
change to the ground.
Just so the etcher's acid
runs and carries
equally on all four films.
The emulsion swims
in water now,
free of you.

Boardwalk

Walking almost barefoot,
alone along smooth boardwalk,
my hand fans out to hold
a friend's, dead twenty years.
Touching a rough, sear wall,
I sense again a breeze between
my dry, lacing fingers.

Now Your Hair

I. Then Surgery said:

Cut & shave away
every hair,
prepare to clean,
the incision draws near.

The answer
is a razor
to the point,
sharp.

Minutes later,
the generous nurse appeared
with the clear bag
of your torn shirt and long hair.

II. Now prepare:

From the back I think I see you
twenty years out, but you have not greyed.
I cannot even wait your turn,
I am fixed so on the long, brown hair
which I now remember
lies waiting for my son
in a wooden box
set behind.

Light, bright or soft

I am instantly in love
with the memory of darkness
that follows the still afterhours.

Touching the slow slug
with a bent stick. What a wet mess
of mistakes we made.

Crossing that same curb,
aware of the shorter shadows.

 Swiftly
I walk the block in dark hours
and find a lit door
to walk back
through.

Alice

Night silence is not this night
since the winds blow leaves on leaves.
You asked me lightly to tell you
for what on earth I was waiting
to live here now in response.
I close like fingers around
a branch, struggling not to fall.

Your feet are inches off the ground,
it is well written down.
I want to trust you with dreams,
yet in my sleep I thrust out
and fight back.
 A free miracle
my block out does not block up.
Unusual: you sleep while
I sit in the dark room, hear
the leaves move on glass panes,
I know I should give it up,
fall. I will weaken soon enough.
In our short play,
call the full curtain.

Eventime

Tea with lemon, coffee with cream,
sex with breath, sleep with dreams.
Fears of death, peace in your arms,
stars in the heavens keep us calm.
Wind in the curtains heals our aims,
Hands together play new psalms.

DREAMERY

The first and second wife walked on till dusk,
Though one was dust and two was flesh,
Until they reached my store of books, of course.
We read and read together across each page
Though every book tipped in another tongue.

After I ran an errand, I returned:
time had past; slim chest of gone wife one
had caved in on its self: I held in my hand
her beaten heart which, when I reached it back,
passed through thick air into your hands, oh wife.

Subtraction

My seven-year-old son says
take away is the hardest.
He knows only adding days;
he cannot lighten
what looms: out-stretched
grown-up arms, freeway lanes. Wish
him on his way, a part of
accumulating steps.

On
Waiting On

I waited for you in coma.
Wake up? Yes.

I waited for your recovery.
Yelled out for food, in fear.

I waited, I waited.
Plateau stayed, grew on.

I waited for you to die.
I died.

Now, Jake,
you wait for Lynn,
for your Mother
to come home,
to find you.

Waiting works
on you.
Stop.

Headed

to my son

Drifting.

The bigger ball pauses
in flight down.

The wet field is still
small behind you.

Your eyes clamp
and clear to a cool breeze.

Where to head?
You are in love with directions.

Tripped & Fell

I keep saying,
Orpheus and Eurydice
over and over.
But you tripped & fell.

You were my snake,
in coma my deceit.

Now in death
my relief,
I cannot stop
turning.

A walk downtown

I never left
town.
And the many whose hands
fed, held, pushed you,
even in coma
to rejoin the world,
stayed in this town.

I meet them on my way,
most knew you'd fade and die,
the Surgeon, who showed me the enormous clot,
the Nurse from ICU, the Rehab PT,
the OB/GYN Resident who caught our son.

I show them
his new picture.
They gasp in and out,
breathe to burn.
For years they were
my way to talk to you.
You did return,
but not to your self.

Now they separate away,
grow wrinkled and real,
faithful friends,
true familiars.
When I see them,
you are almost gone.
Still, I keep your picture close.

Wolfgang Amadeus Mozart

I am playing the Mozart again,
the Piano Sonata
in C, KV 545,
the Second Movement, Andante,
I played on a tape recorder
twenty-two years ago.

It soothed me then as it does now.
My son, in a dangerous womb,
lived a long time
before coming here. What did he hear?
I stood by him inside his mother
sighing to the Mozart notes
he cannot remember now.

Yet he stays, calm in his chair
while his step-mother moves to Mozart.
She has given him a car, his next
vessel going out, safe this time.